Nicholas Nixon

PHOTOGRAPHS FROM ONE YEAR

UNTITLED 31

THE FRIENDS OF PHOTOGRAPHY, CARMEL

IN ASSOCIATION WITH THE INSTITUTE OF CONTEMPORARY ART, BOSTON

ACKNOWLEDGEMENTS

The Friends of Photography and the Institute of Contemporary Art express their joint gratitude to the many individuals and institutions who made this project possible. Our thanks to the Massachusetts Council on the Arts and Humanities for underwriting the completion of this body of work as part of their New Works program, to Robert Adams for his incisive and thoughtful essay and, of course, to the artist himself for his sense of adventure, humor and cooperation. We would also like to thank Peter A. Andersen, Claire Peeps and David Featherstone of The Friends of Photography staff for their contributions; as well as David Gardner and the staff of Gardner/Fulmer Lithograph for printing this volume so beautifully. J.A.; D.R.

THIS PUBLICATION IS SUPPORTED BY A GENEROUS GRANT FROM THE POLAROID CORPORATION

Untitled 31: This publication is the thirty-first in a series of publications on serious photography by The Friends of Photography. Some previous issues are still available.

Photographs © 1983, Nicholas Nixon
Introduction © 1983, Robert Adams

ISSN 0163-7916; ISBN 0-933286-33-3
Library of Congress Catalogue No. 82-084610

COVER: Putnam Avenue, Cambridge 1982
DESIGN: Peter A. Andersen

Preface

Even though it is the nature of the medium to enable photographers to take as many images as their temperament allows, it has been a common practice to work for single "masterpieces", and to consider the remainder of a month's work as trials and, largely, failures. In the past decade, however, certain artists have defined territories of interest that could allow the taking of many successful photographs. The idea of the masterful image became a less important part of the aesthetic vocabulary. Along with this redefinition of what constitutes a successful work of art came a detachment from traditional composition that led to a new visual freedom.

Among the most important, successful and prolific of the photographers who have come to prominence over the past decade is Nicholas Nixon. In an attempt to establish a personal understanding of his vision, he has consciously worked in one-year blocks of time, with new ideas and visual modes evolving in each twelve-month period. The results have been of a consistently high quality and interest. The intensity of his vision speaks directly to such basic concerns as the nature of the human spirit. As one of the select photographers represented by Light Gallery, he chose to have a smaller exhibition there each year rather than to have the traditional biennial show. Functioning as a personal culmination for a group of pictures, this annual presentation allowed him to bring one set of ideas to completion, and to move purposefully on to the next.

Thus, the commission offered by Boston's Institute of Contemporary Art in the summer of 1981 to create a body of photographs to be exhibited in the Institute's gallery only weeks after its completion supported a continuation of his way of working. It is a great pleasure for The Friends of Photography to be able to publish these photographs made over the course of one year so soon after the time of their making.

James Alinder, *Executive Director*
The Friends of Photography

Foreword

There are many ways to tell a story. Some might say that this truth springs from the fact that the narrative impulse underlies all human interaction, and perhaps is its essential quality. In the ongoing recapitulation and refinement of this impulse within the art of this century, the photographs of a handful of artists have successfully expanded our sense of story-telling. Nicholas Nixon, emerging out of the tradition established by Eugene Atget, Walker Evans and Wright Morris and whose current standard-bearers include Robert Frank, Lee Friedlander and Garry Winogrand, is a photographer whose art has challenged our presumptions about the balance of formal picture construction, character (or landscape) study and humanity expressed not as the concern of a removed observer, but as the record of an essentially loving interaction.

In this selection of photographs produced by Nixon during the last months of 1981 and the first half of 1982 Nixon's spirit and craft are fully evident. The contact prints reproduced in this volume, and which were contained in the exhibition produced by the Institute of Contemporary Art, are bursting with story yet each is quite complete as an evocation of that which can survive beyond (or outside of) the language of words.

David A. Ross, *Director*
Institute of Contemporary Art

4

Introduction

BY ROBERT ADAMS

It is the large scale of Nick Nixon's purpose, not of his 8x10 camera, that distinguishes him. He has taken on the hardest job of all—to convince us of the worth of our lives. As he put it years ago in a letter, the pictures he wanted would be "ways of understanding and *respecting* the world." To try for that kind of affirmation is now, if you listen to some, hopeless, but fortunately for us Nixon has a New Englander's disinterest in the easy.

Of course the first thing that he has to do to win us away from our despair is to admit the evidence that supports it. There it is—graffiti on the wall, people poor and tired, children sometimes alone, old age humiliating us. . . . If sentimentality is, as Joyce remarked, "unearned emotion," then Nixon tells us right away that he's not going to allow it; we're going to have to pay.

With that established, he tells us stories. Nixon is, like many photographers past and present, unusually literate, and his pictures appear in part to originate with a writer's impulse as they depict complex events in progress. Nixon tells us these stories, it seems to me, out of an affection for us, and because he is not a philosopher. One says both things with gratitude. When we are young we are likely to regard artists with a certain annoyance, prone as they are to anecdote; they seem all to be middle-aged, we grumble, having noted what we take to be cowardice in older people's reluctance to theorize with us about life. But the fact is that talk concerning abstractions, though it is pleasant at the time, cannot go on because it is composed mostly of speculation about experience. Eventually one undergoes the experience itself, and it is not highly arguable—it is just there. One comes to see that telling stories—narrating experiences—is a way, whether in private life or in art, of continuing conversation.

It has been lamented by many contemporary writers, however, that it is hard to find believable endings for stories. No conclusions seem probable in a world as disconnected as ours. Nixon, who presumably feels some of this too, as do we all, nonetheless believes that there is significance to life, even if we cannot fully understand it, and he has as a photographer been able to solve the literary difficulty with a visual solution (photography is, he has written, "on a continuum between the literary and the painterly"). What Nixon does is to place his subjects—many and varied and sometimes active—into stable visual relationships, creating an equivalent of a completed plot, an expression of the artist's belief in coherence. Nixon first came to prominence, it is germane to remember, as a photographer of large cityscapes, and he has more than once described his later pictures of people as involving, at least to a degree, "landscape problems," by which he means problems in linking components, human and otherwise, into a balanced whole. Also relevant, perhaps, is the fact that he tried using an 11x14 camera, but abandoned it, one suspects, for formal reasons; the longer format edged him back toward the literary puzzle, toward vision that does not so much stabilize our view of a scene as encourage our eyes to progress from one side to the other across it.

What Nixon's pictures provide, then, are alternatives to the often forced, dubious conclusions in literature. In their place he stops his narration in such a way that the action is given the beauty of a mosaic such as Yeats envisioned, a view beyond "what is past, or passing, or to come."

Related to this achievement, Nixon has caught his subjects in ways that suggest they are aware of their importance, of their participation in the mosaic. There is a sense of stylized gravity in much of their behavior that recalls the paintings of Piero della Francesca, though in Nixon's pictures it is ordinary life that is revealed, by his subject's solemnity, to have the seriousness of ritual. Again, one is reminded of Yeats: "How but in custom and in ceremony are innocence and beauty born?"

All that being said, however, it must be admitted once more, as Nixon clearly intends us to acknowledge, that there intrude into life elements reminiscent of those in pictures by Diane Arbus (Nixon at one time kept a large print of the sword swallower on his living room wall). Children in

6

his photographs hold toy weapons, for example, and retardation is sometimes implied; occasionally, as in the picture (PLATE 10) of the two boys hugging—or wrestling—there is the suggestion of ambiguous threat. We are reminded that though life may at some ultimate point be a balanced unity, there remain elements that will, to our limited vision, always appear disruptive.

Nixon's pictures as a whole suggest two consolations beyond the unprovable fact of the mosaic. The first Nixon offers even in the quality of his prints, which are on Azo contact paper and are tonally rich. Relatedly, the pictures show many heavy figures, much gleaming flesh and a great deal of sexuality. People enjoy what their bodies tell them, children especially. Look at the ecstatic with his face turned to the sun, his arms outstretched and his pants unceremoniously falling off to reveal a torso worthy of Weston (PLATE 7). Nixon is, in short, a sensualist. Whenever he can manage it, for example, he bathes people in a shower of natural light, that illumination the cinematographer Raoul Coutard aptly called "always perfect." Just a visit to Nixon's third floor apartment, in fact, tells you what he enjoys. It is sparely furnished, but the living room has on three sides large windows that give views across Cambridge and in turn allow a complex radiancy inside. Light has, certainly, many kinds of significance, but the first that occurs to one in that room is simply the intense pleasure it affords the eye. Perhaps the most concise acknowledgement Nixon has given of his sensualism, though, was in a picture he took years ago of a pillow. It is shown feather-full, rounded inside a pillowcase printed with tiny flowers; the bed on which it is set is made with an old quilt and stands next to a wall papered in a design of flowers, leaves and berries; window and lamplight brighten a corner of the pillow. Life, the picture makes clear, can be very, very soft.

If the senses can be a joy, however, they are also vulnerable. Look if you can at the agony of that brittle, knotted, atrophied leg which the elderly lady (PLATE 11), for all her beauty, has to endure. To this kind of affliction Nixon offers in his photographs evidence of one final consolation —human tenderness. Affection and gentleness are apparent in the pictures to an extent few other important photographers currently dare; sometimes the qualities are overt, as in a young mother's embrace or an elderly mother's consoling hand (PLATE 39), but as often the warmth is shown simply

in the contentment of those generous enough with each other to be close.

Many have speculated about how Nixon manages to get these pictures, which depend on the cooperation of strangers from economic and racial backgrounds distant from his own. The answer is necessarily in the nature of the photographer himself. Nixon is a gentle, deeply compassionate man. To those who have only met him in the context of a lecture or a seminar this may be slightly surprising, since he has a reputation for being uncompromising in those situations (any artist knows the reason why—to protect the energy and self-respect needed to continue to make pictures). On a personal basis, though, Nixon is among the most unfailingly considerate of persons (I can hear him say to that, "I'm no saint."). No more evidence of this is required than the pictures. If you work with a camera that makes disguise impossible, your subjects have to believe in you, and these people obviously do. He tells them when they ask if he will send them a print, for example, that he will, but only if he gets a good picture. That could be a dodge, but it is also the only response open to a man who honors his subjects, and they credit him with that.

Nixon's work is set apart, surely, by those single pictures that are perfect in their loveliness, that show us wholly as we would wish. One thinks of the girl and boy at the screen door in Allentown (PLATE 14); of the brothers in Lakeland, the older of whom is about to leave for the army (PLATE 18); and of the sweet children on the porch in Clearwater (PLATE 25). As much as we remember these views, however, it is the totality of all the photographs that makes Nixon's work so valuable. We realize only upon review of figure after figure in picture after picture that there are no villains—none. No one is contemptible (for comparison, think of photographs in news magazines). More astonishing, there is not a face that is uninteresting, not an individual for whom we could not hold some respect and hope.

Robert Adams, a prolific and widely recognized photographer living in Longmont, Colorado, has often written thoughtfully about the medium. His book of essays Beauty in Photography, Essays in Defense of Traditional Values, *was published in 1981. He was recipient of the 1982 Peer Award in Creative Photography as "Photographer of the Year", presented by The Friends of Photography.*

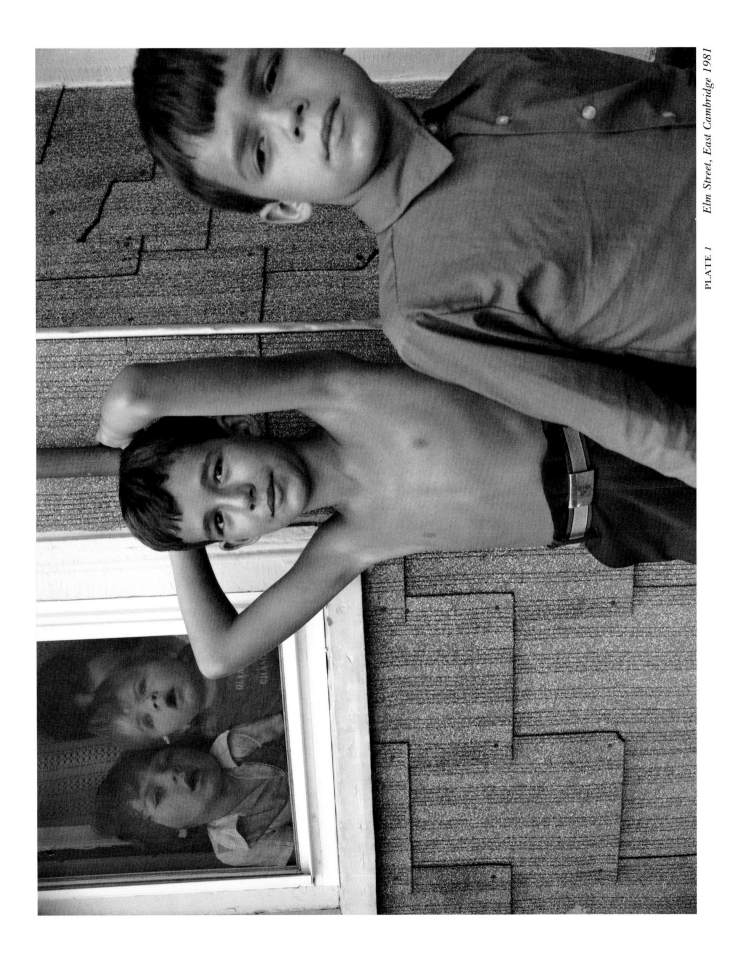

PLATE 1 *Elm Street, East Cambridge 1981*

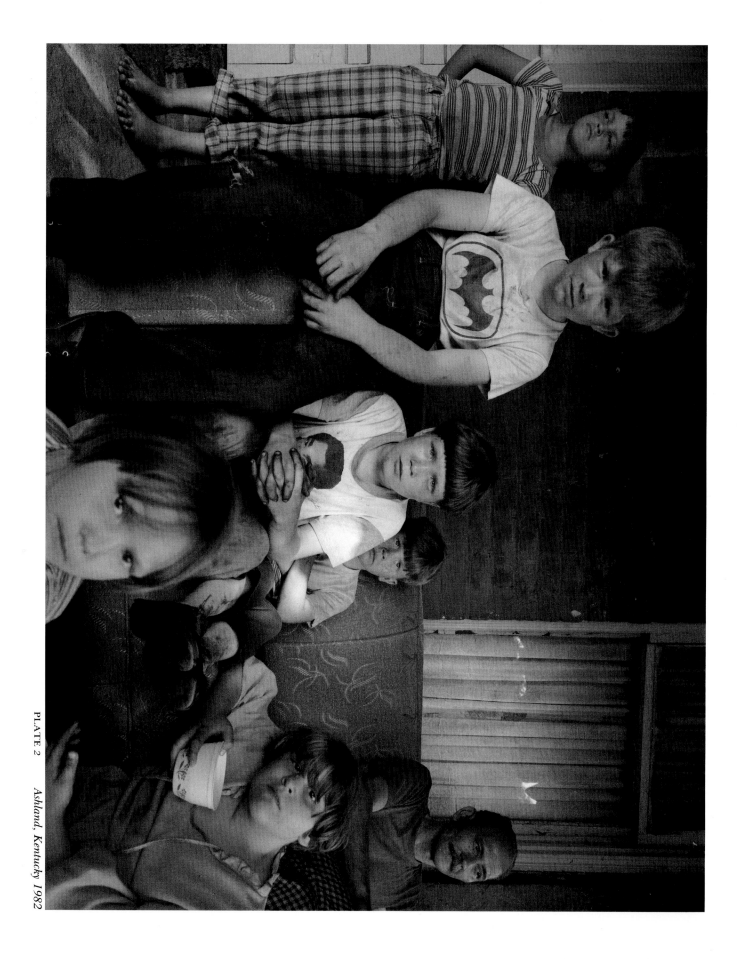

PLATE 2 *Ashland, Kentucky 1982*

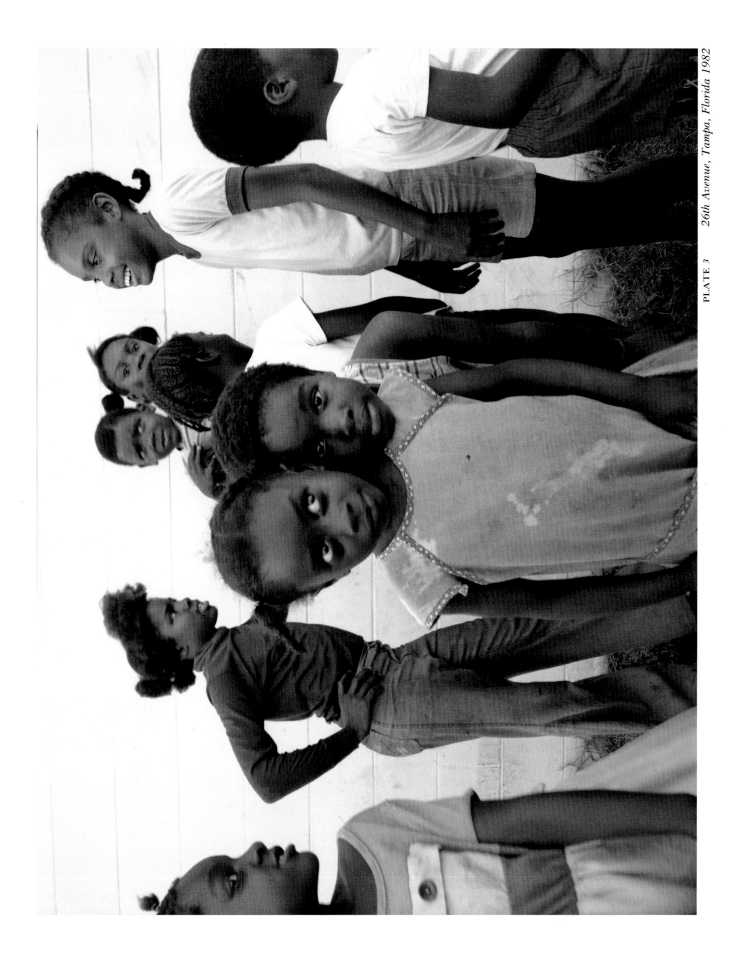

PLATE 3 26th Avenue, Tampa, Florida 1982

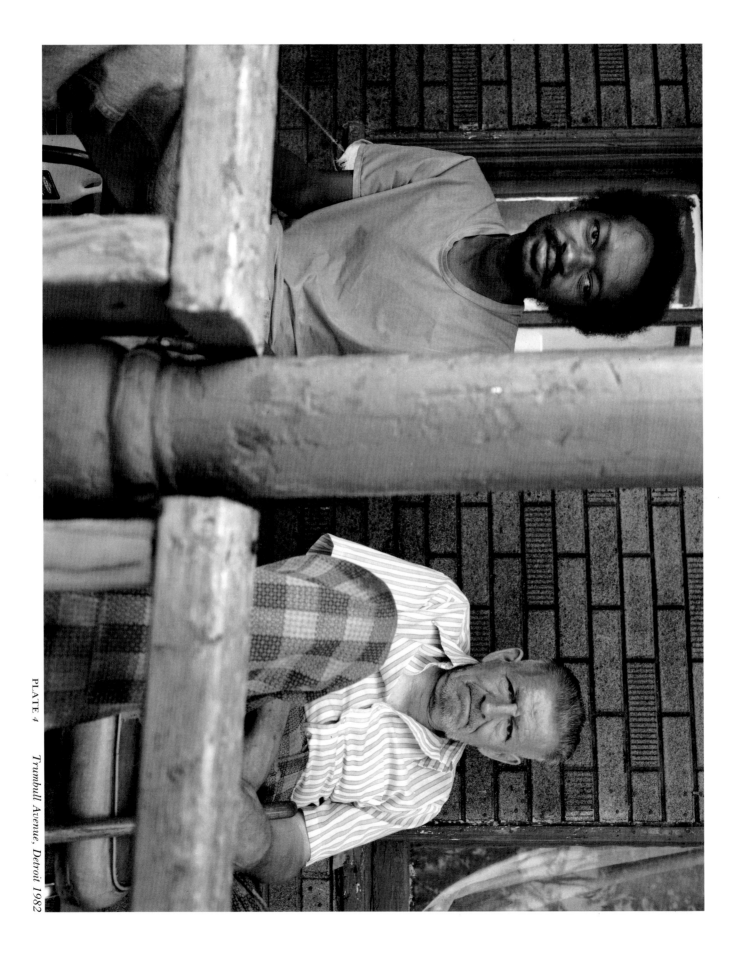

PLATE 4 *Trumbull Avenue, Detroit 1982*

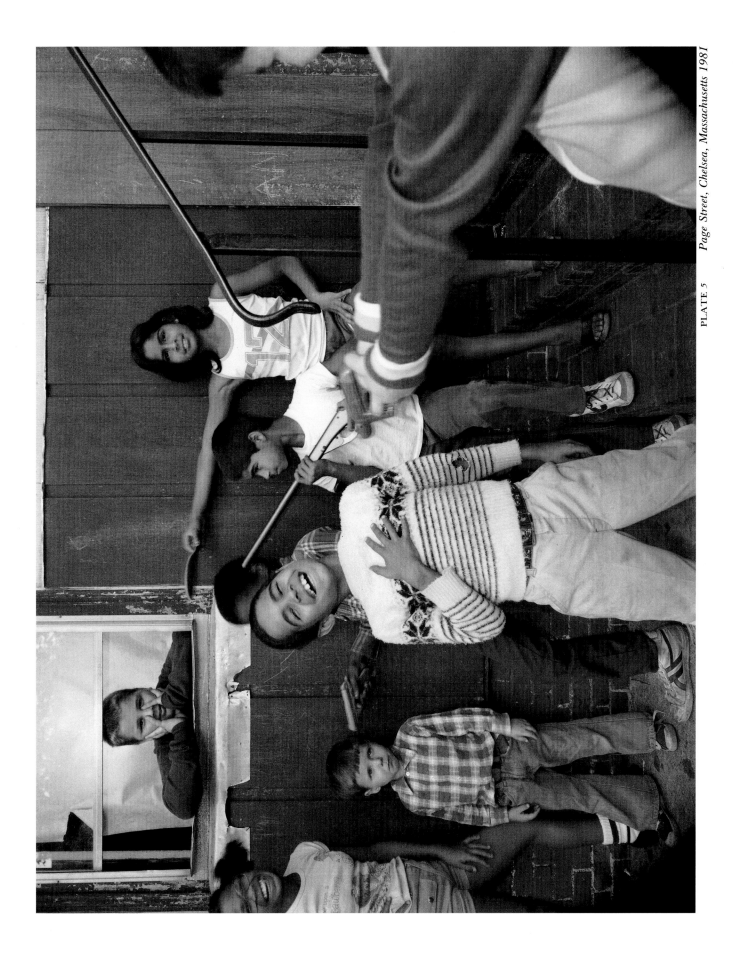

PLATE 5 *Page Street, Chelsea, Massachusetts 1981*

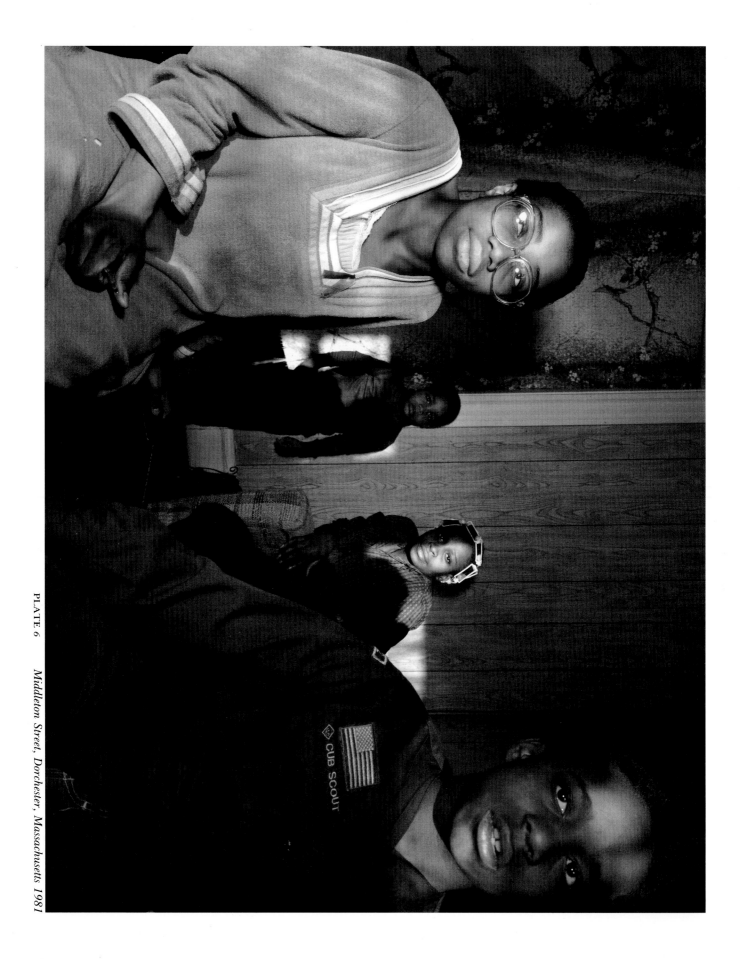

PLATE 6 Middleton Street, Dorchester, Massachusetts 1981

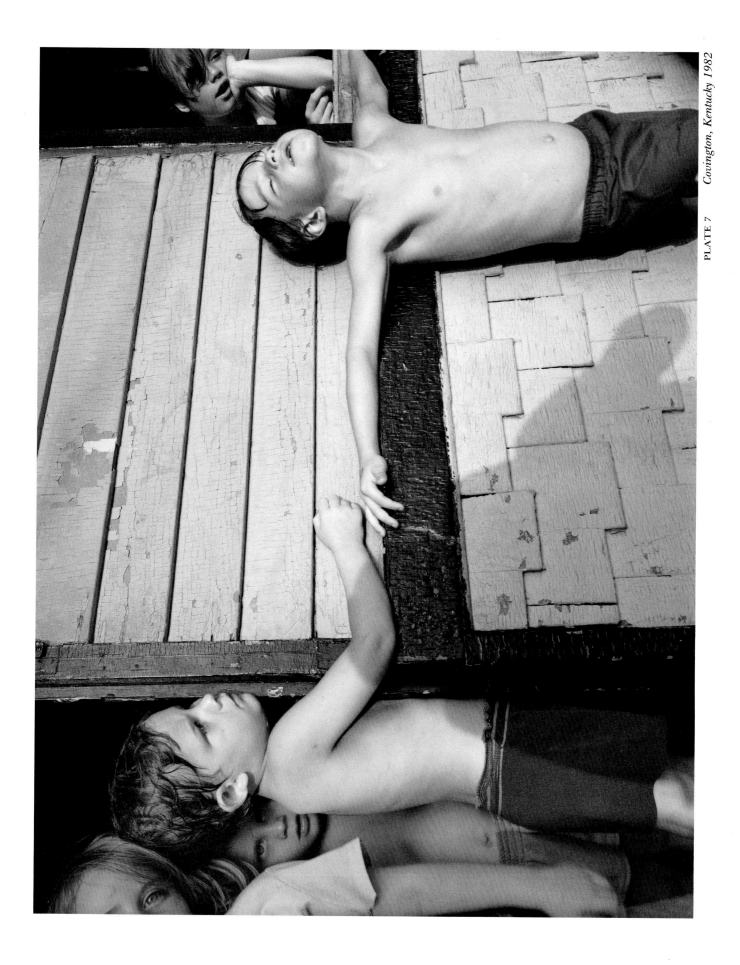

PLATE 7 Covington, Kentucky 1982

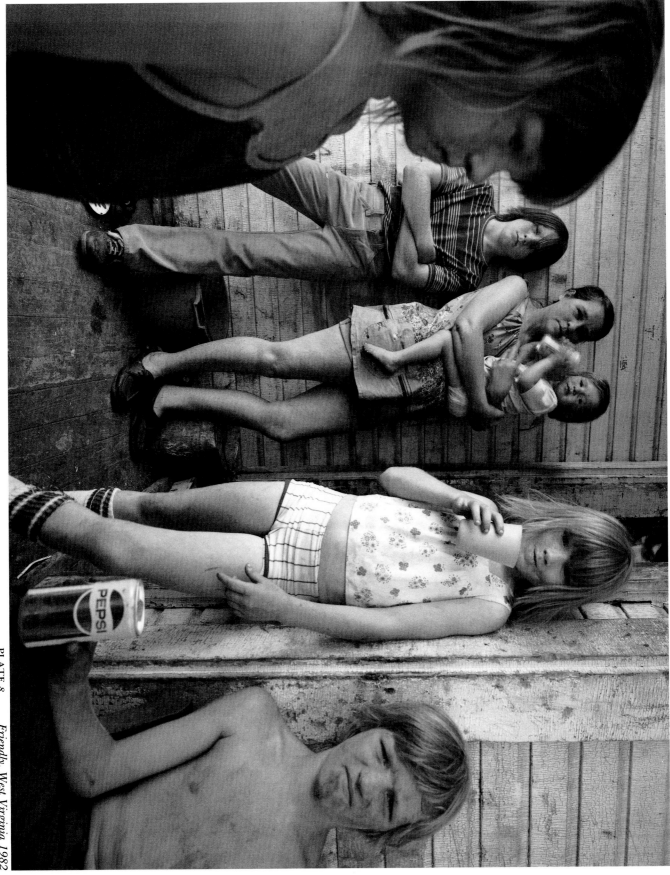

PLATE 8 *Friendly, West Virginia 1982*

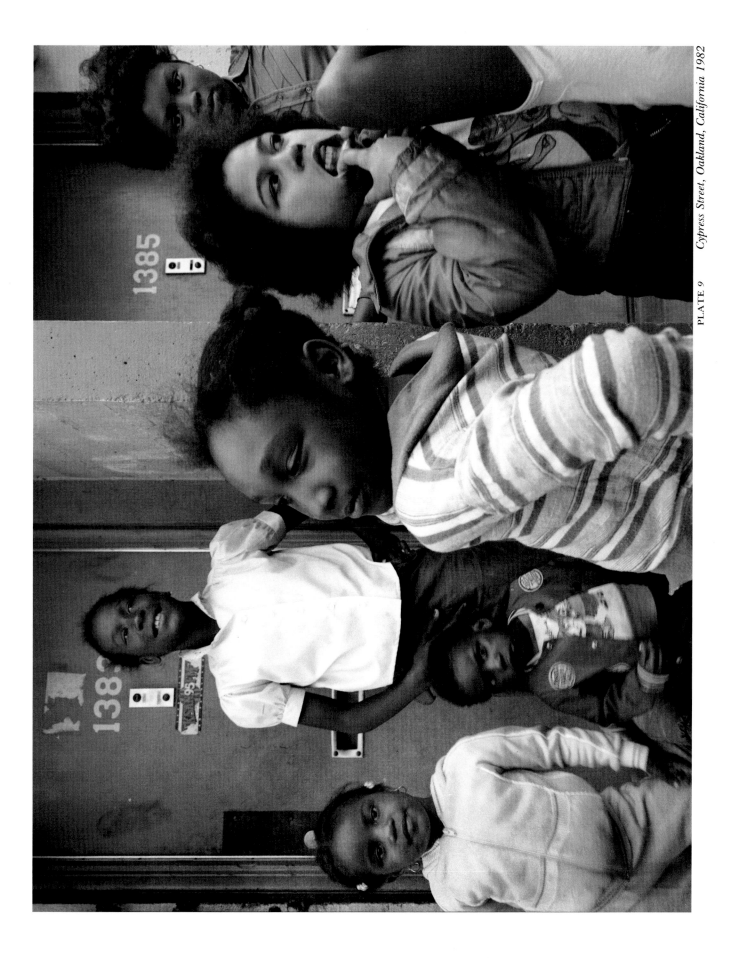

PLATE 9 *Cypress Street, Oakland, California 1982*

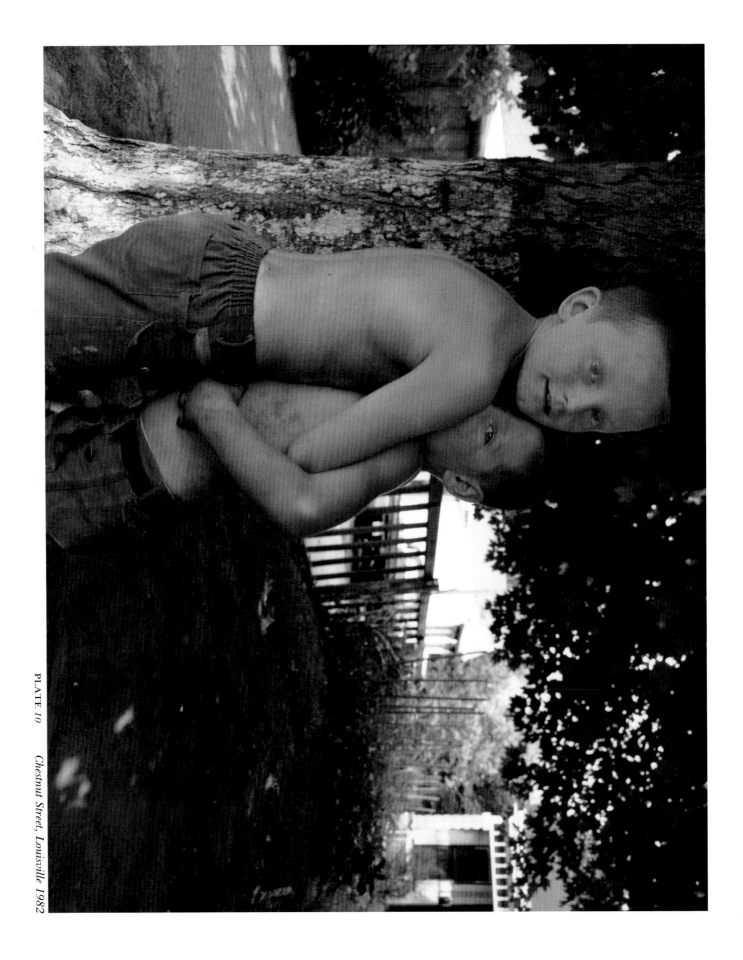

PLATE 10 Chestnut Street, Louisville 1982

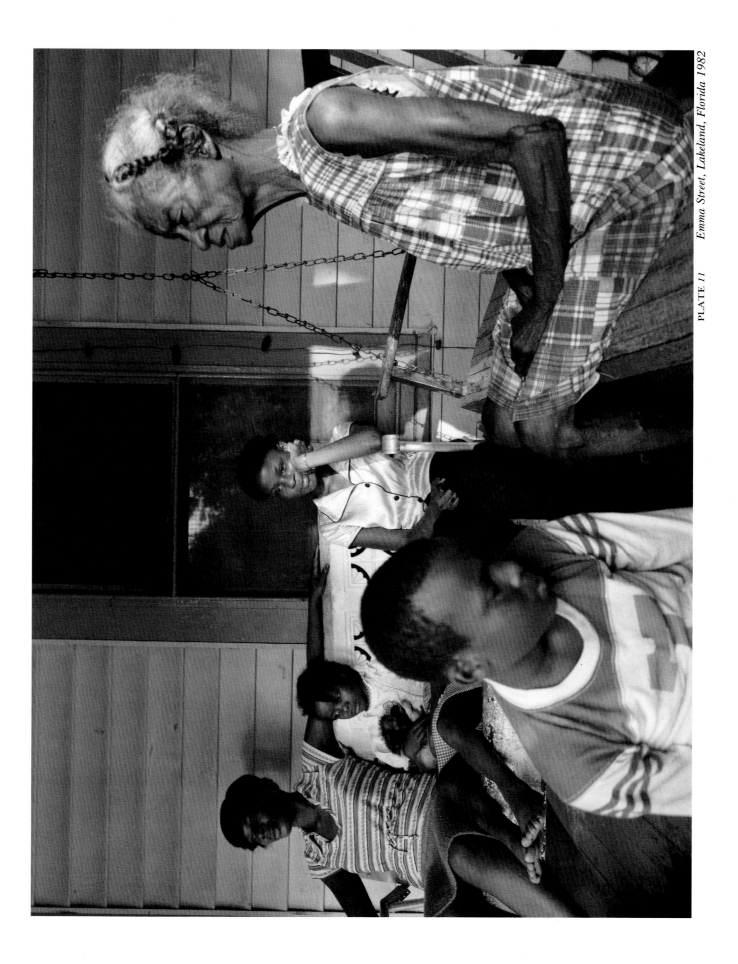

PLATE 11 *Emma Street, Lakeland, Florida 1982*

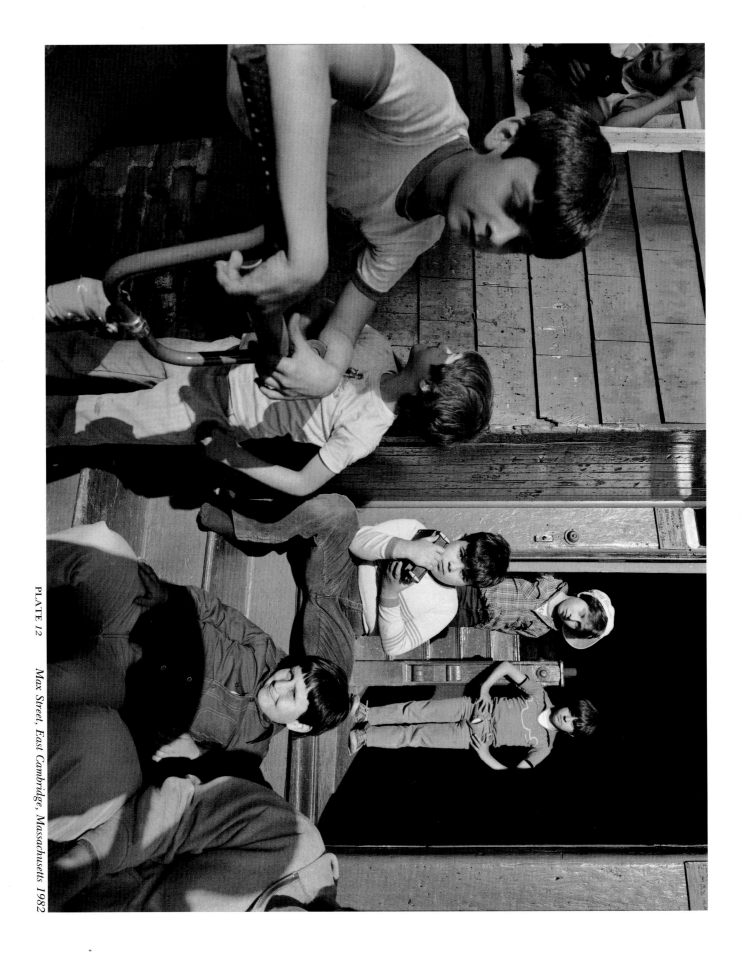

PLATE 12 Max Street, East Cambridge, Massachusetts 1982

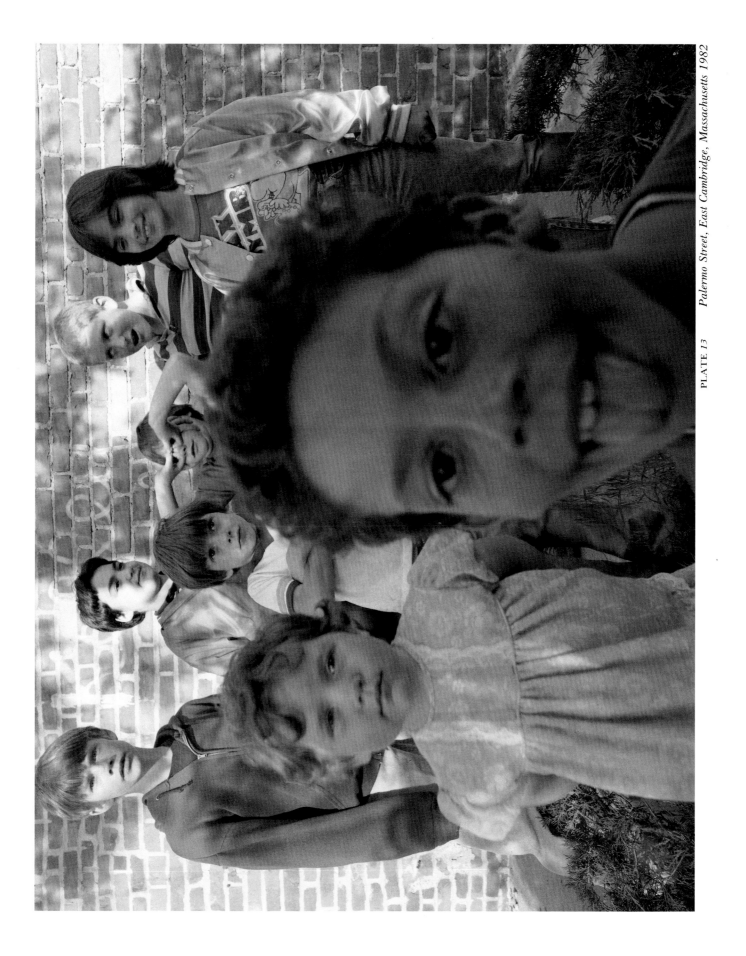

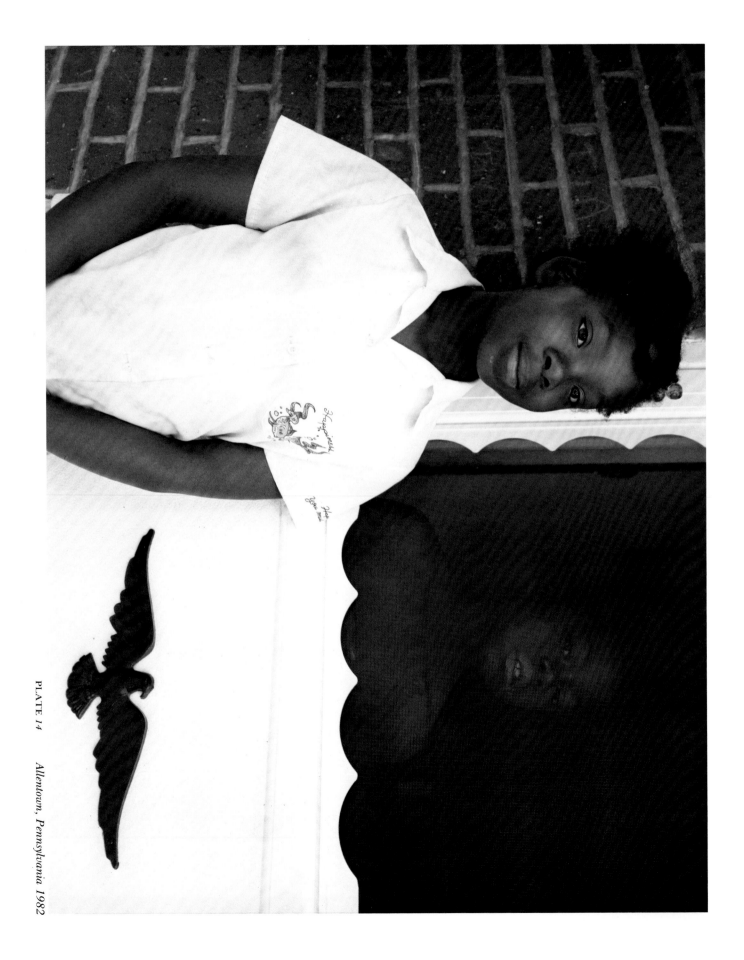

PLATE 14 Allentown, Pennsylvania 1982

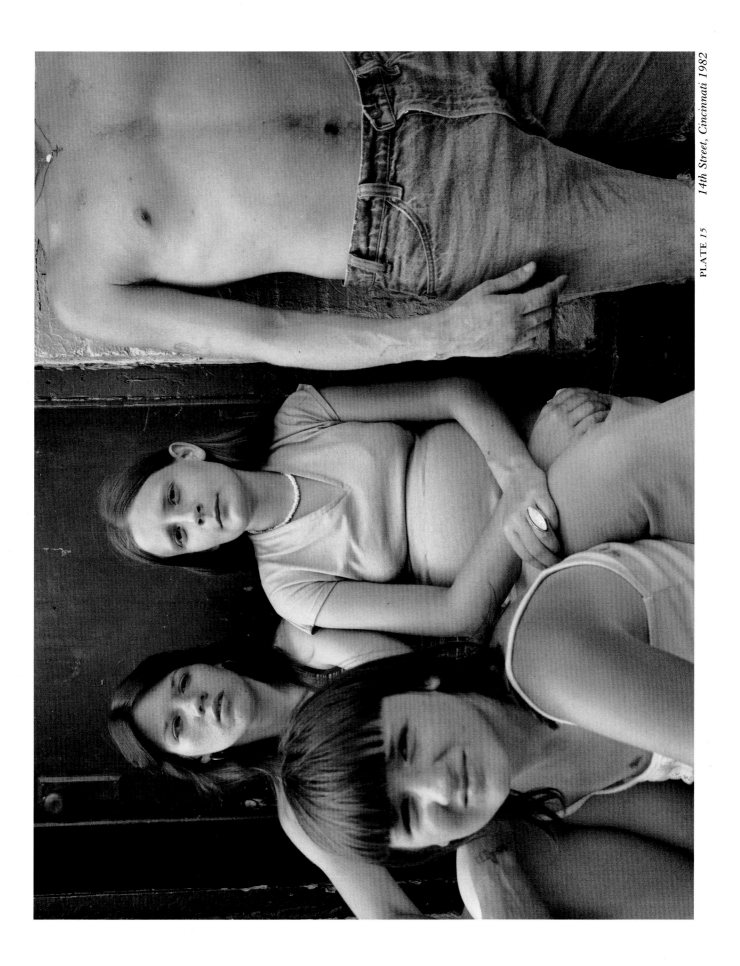

PLATE 15 14th Street, Cincinnati 1982

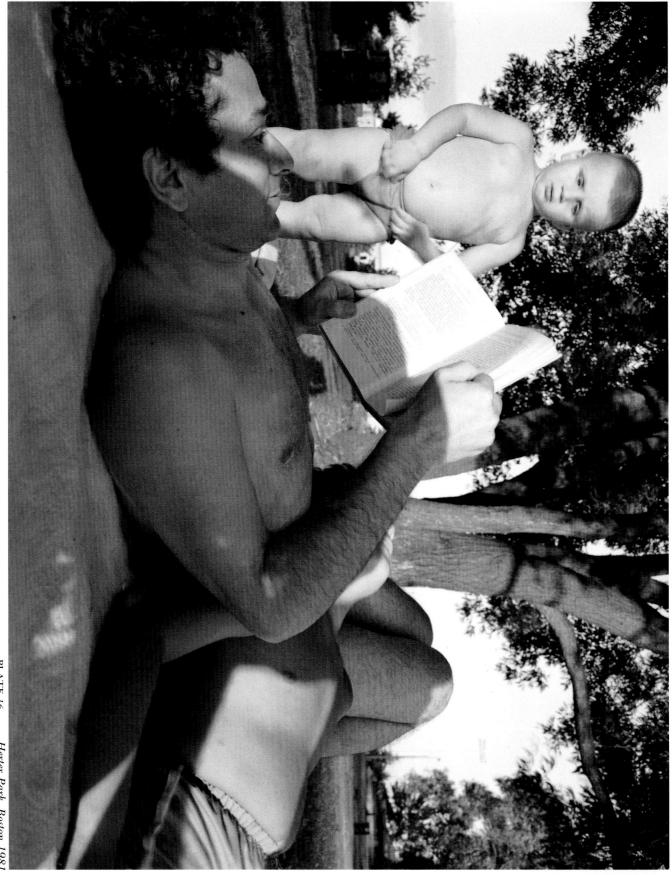

PLATE 16

Herter Park, Boston 1981

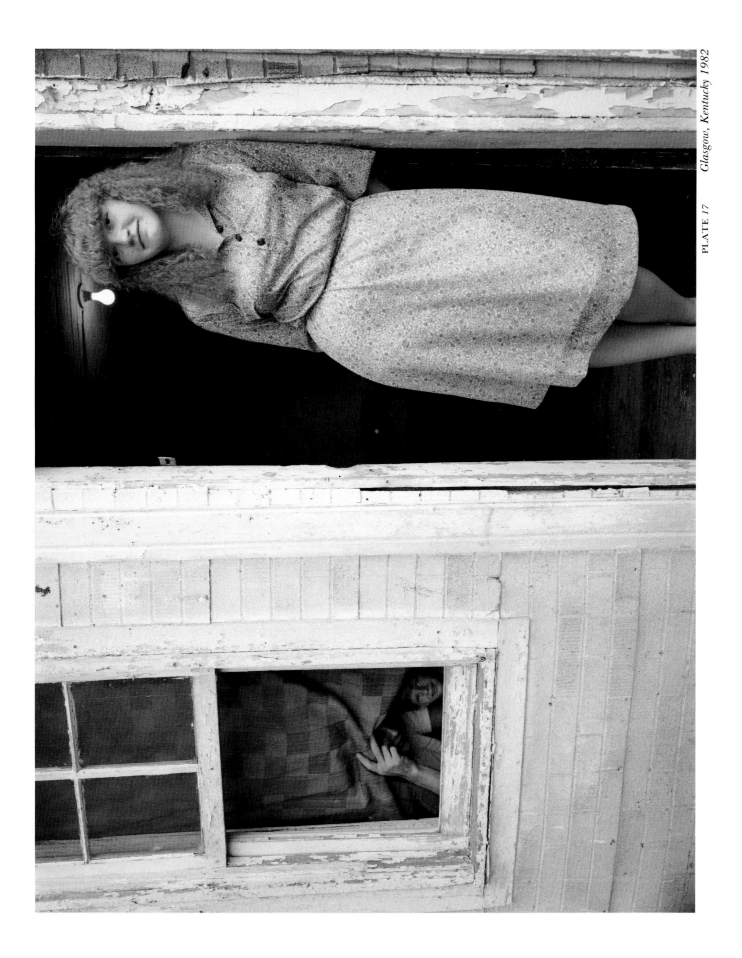

PLATE 17 Glasgow, Kentucky 1982

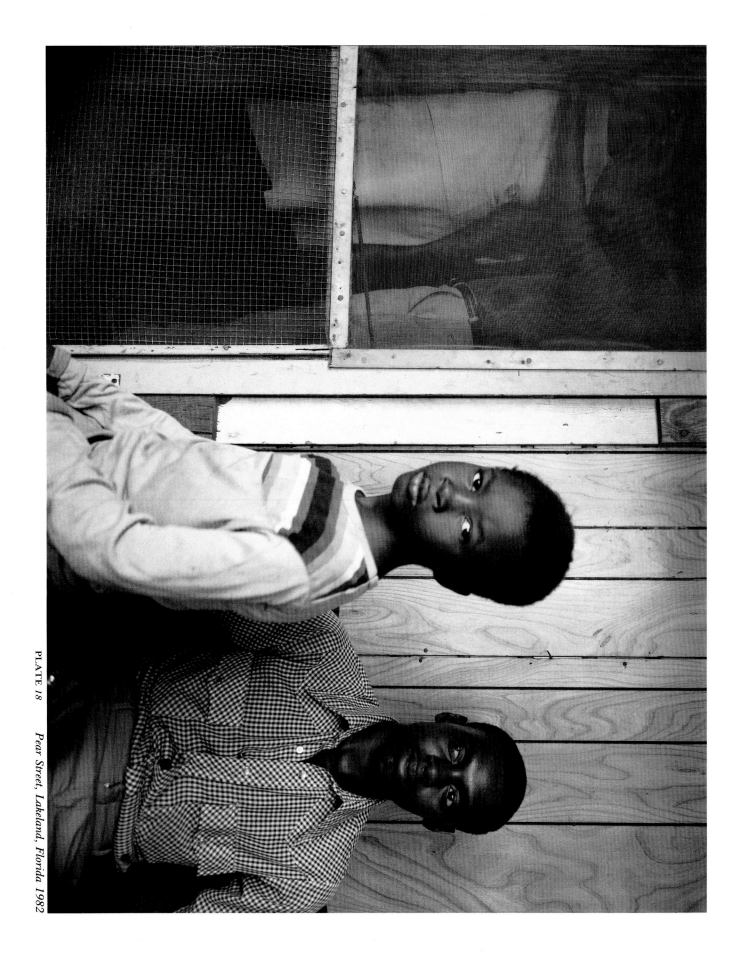

PLATE 18 Pear Street, Lakeland, Florida 1982

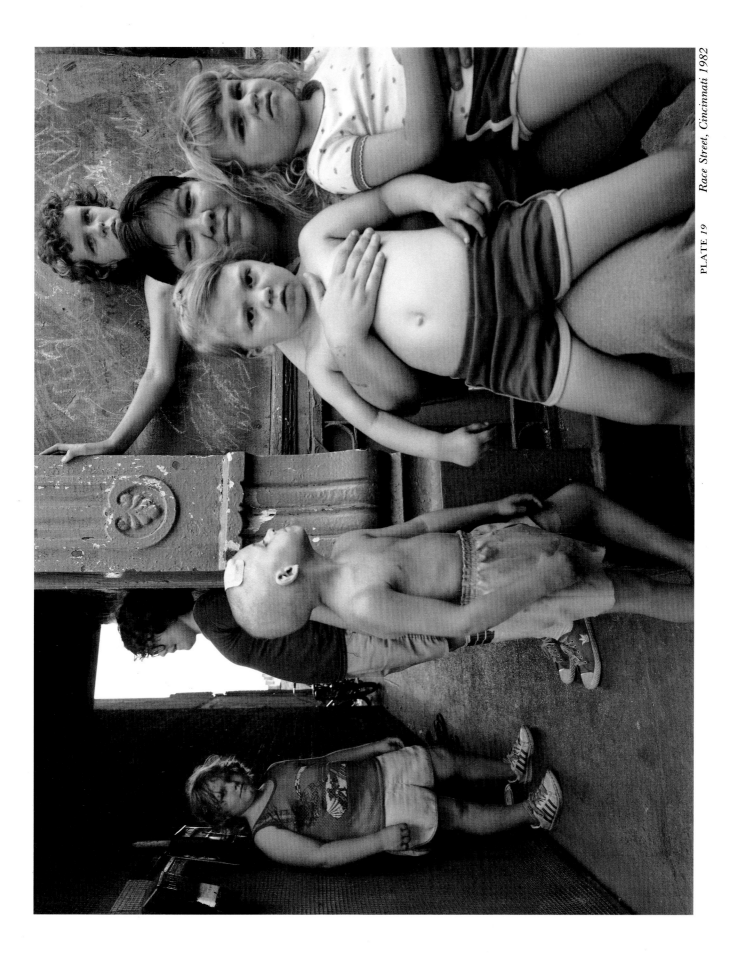

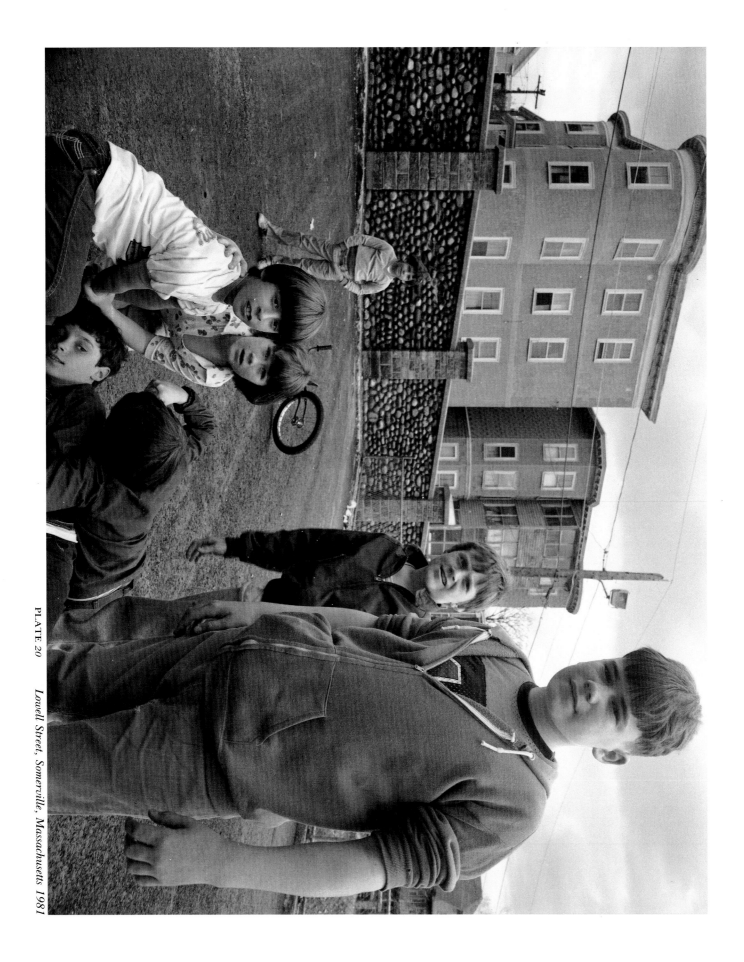

PLATE 20

Lowell Street, Somerville, Massachusetts 1981

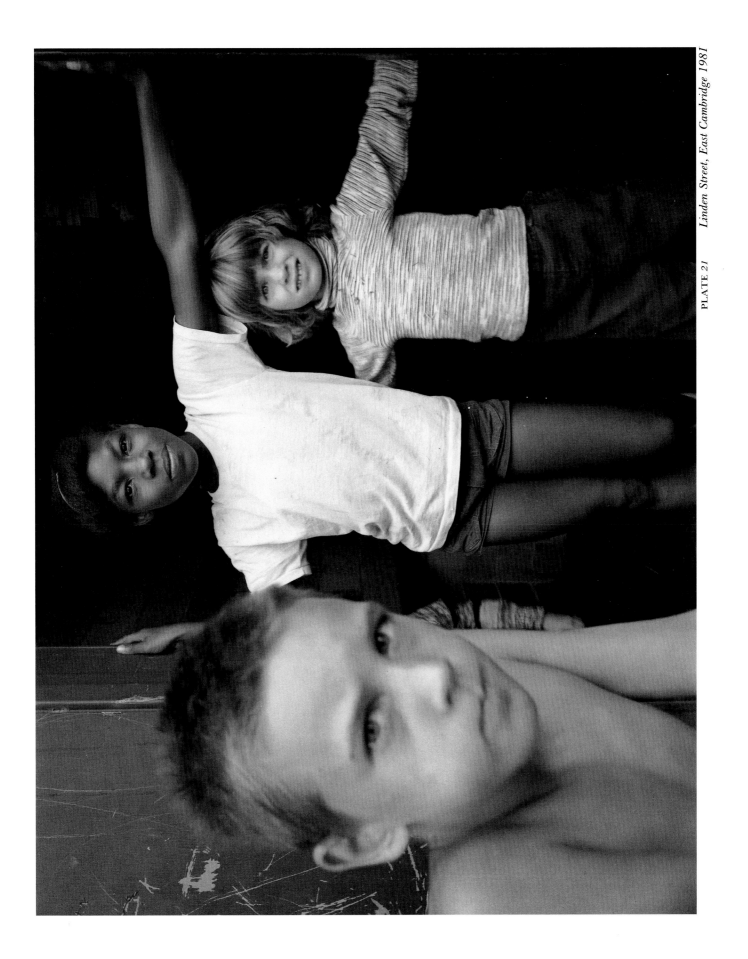

PLATE 21 Linden Street, East Cambridge 1981

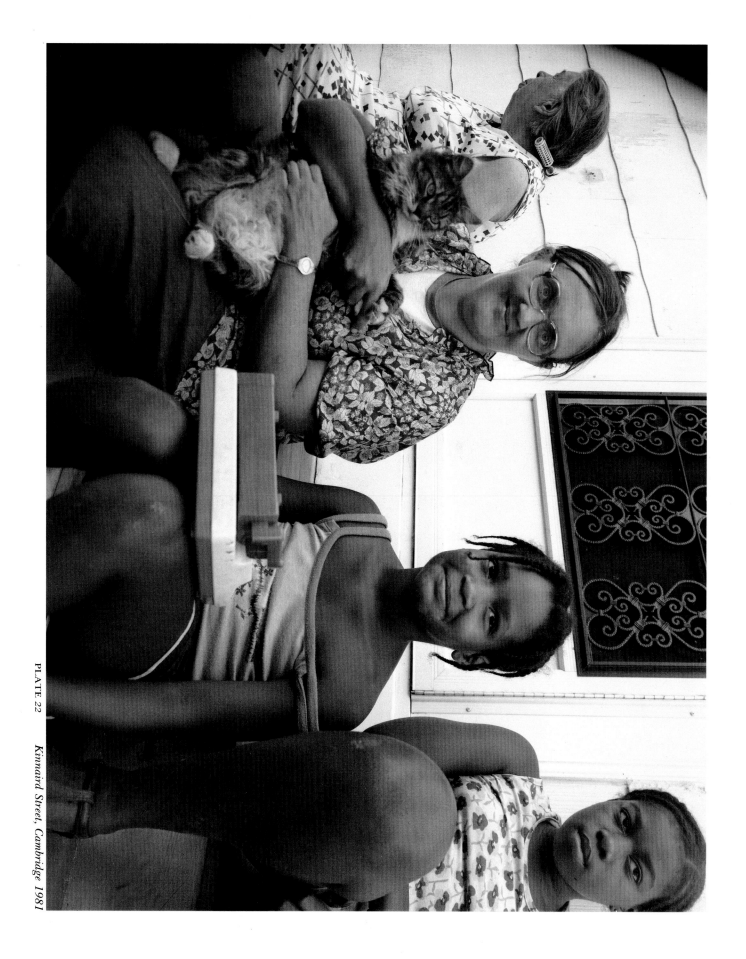

PLATE 22

Kinnaird Street, Cambridge 1981

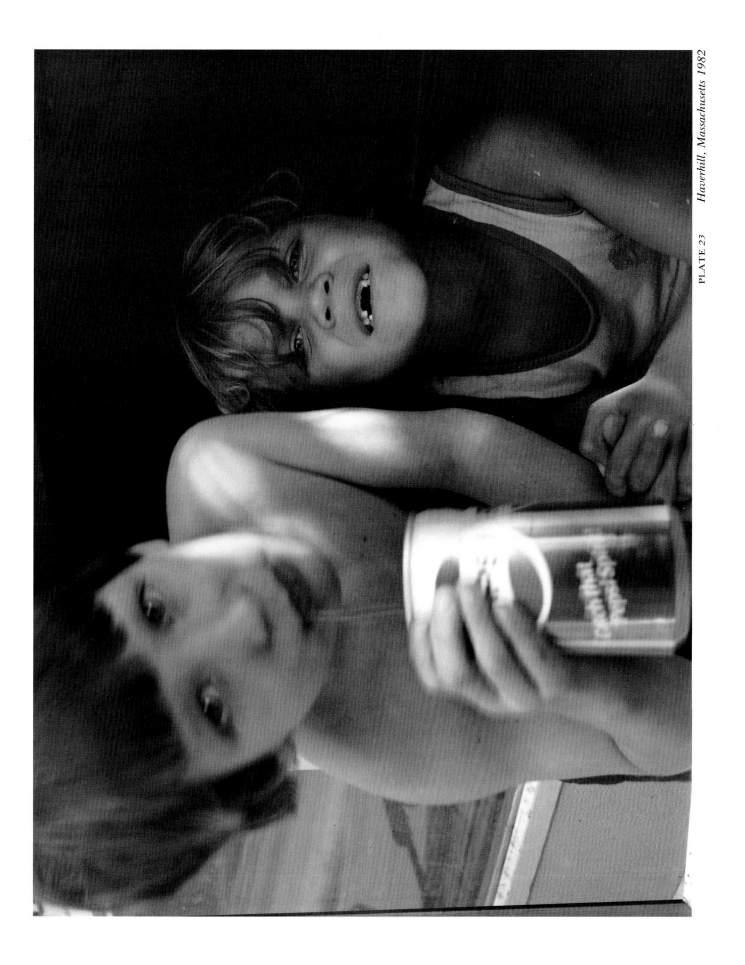

PLATE 23 *Haverhill, Massachusetts 1982*

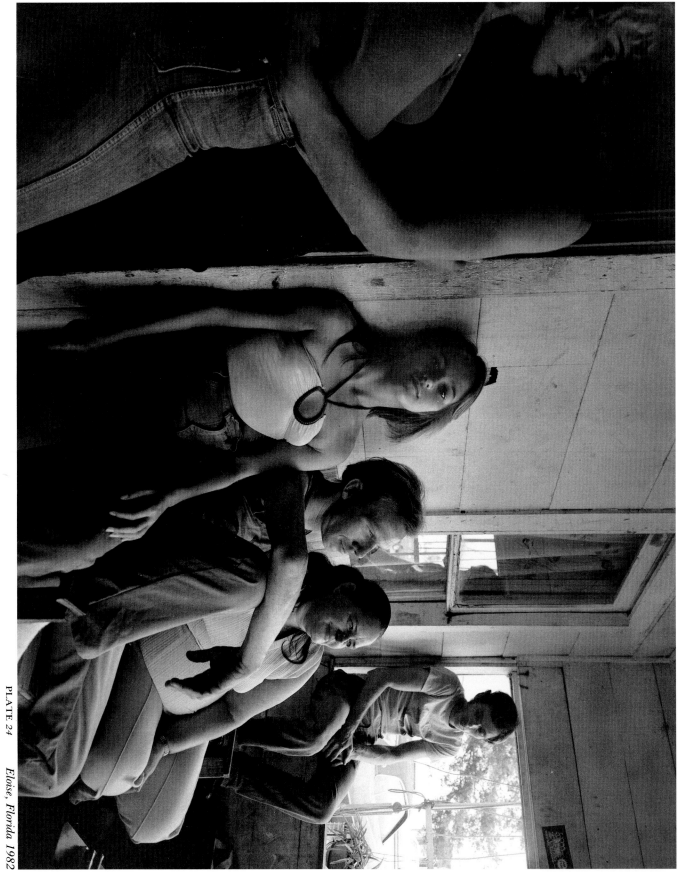

PLATE 24 Eloise, Florida 1982

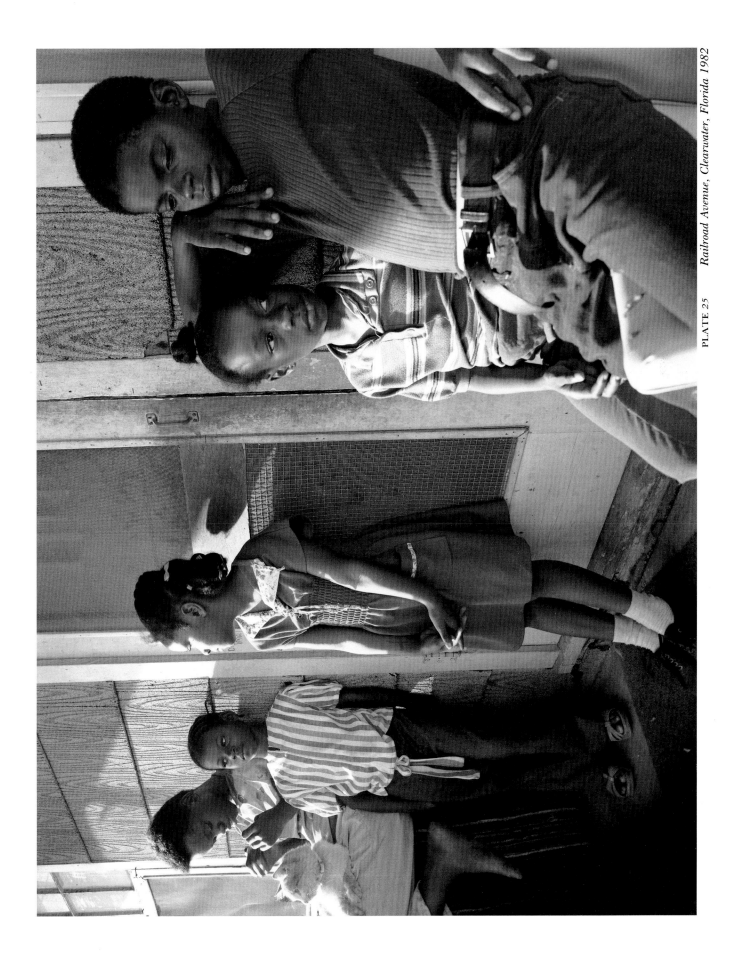

PLATE 25 *Railroad Avenue, Clearwater, Florida 1982*

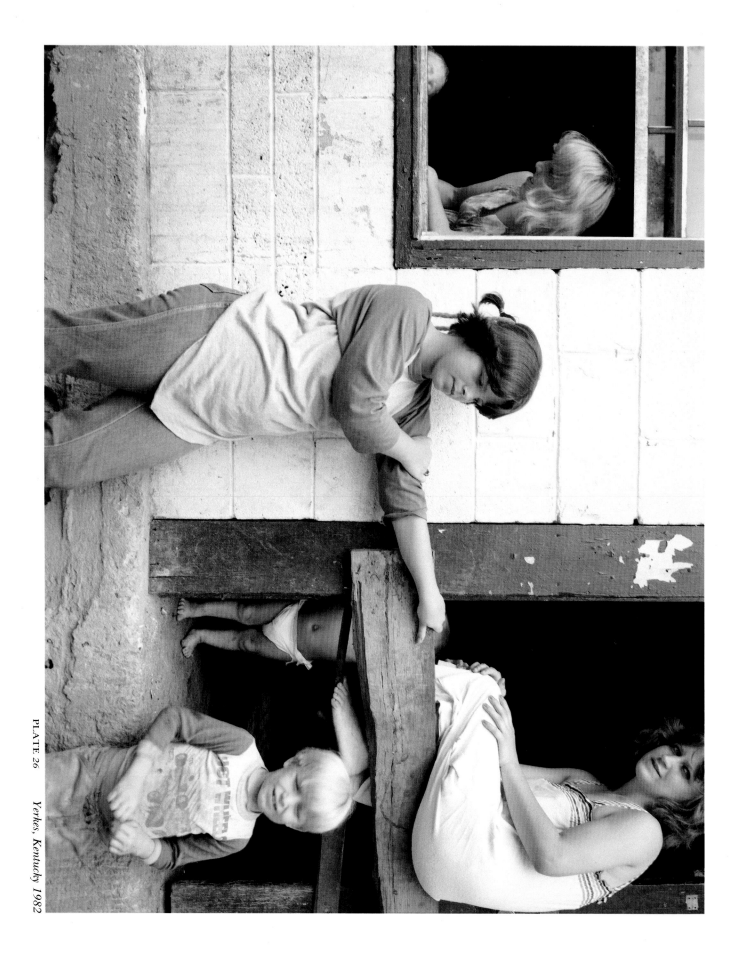

PLATE 26 Yerkes, Kentucky 1982

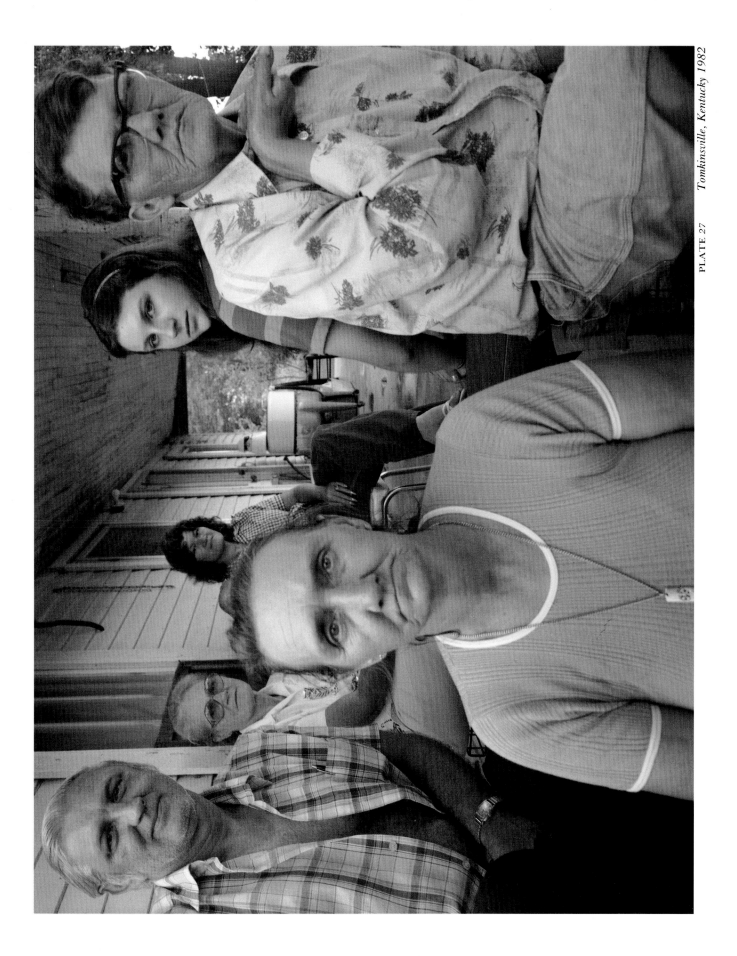

PLATE 27 *Tomkinsville, Kentucky 1982*

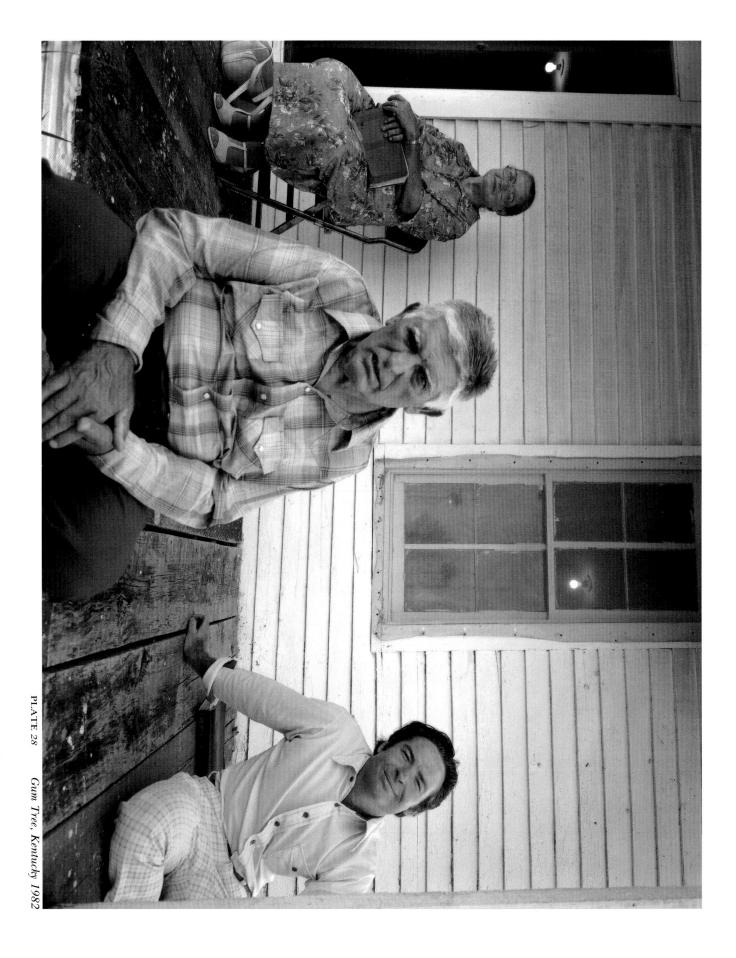

PLATE 28 *Gum Tree, Kentucky 1982*

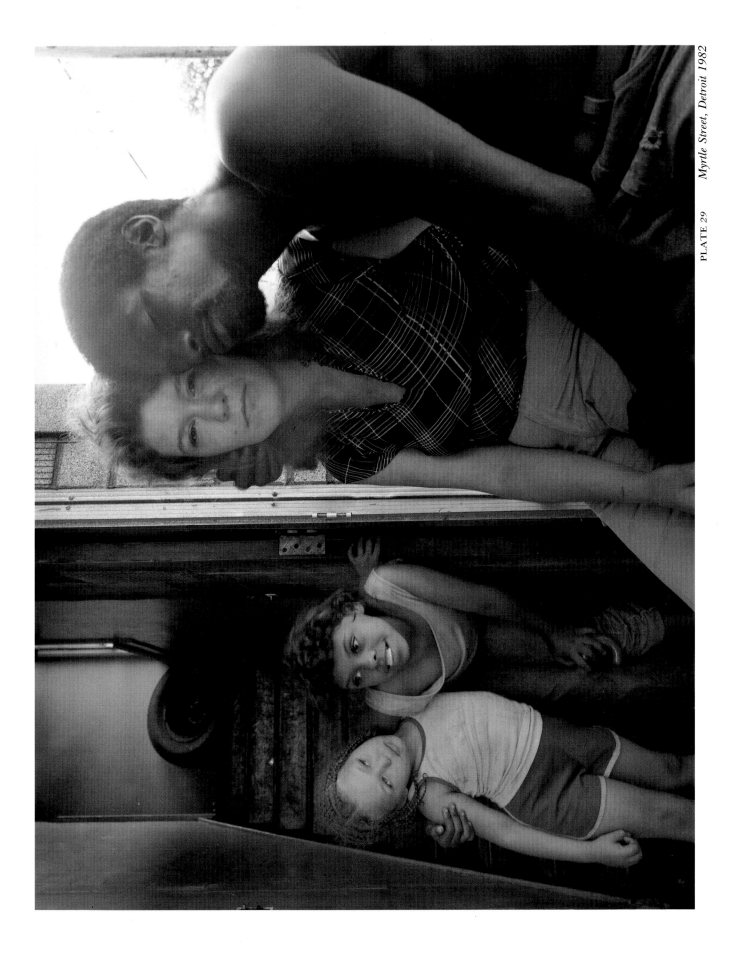

PLATE 29 *Myrtle Street, Detroit 1982*

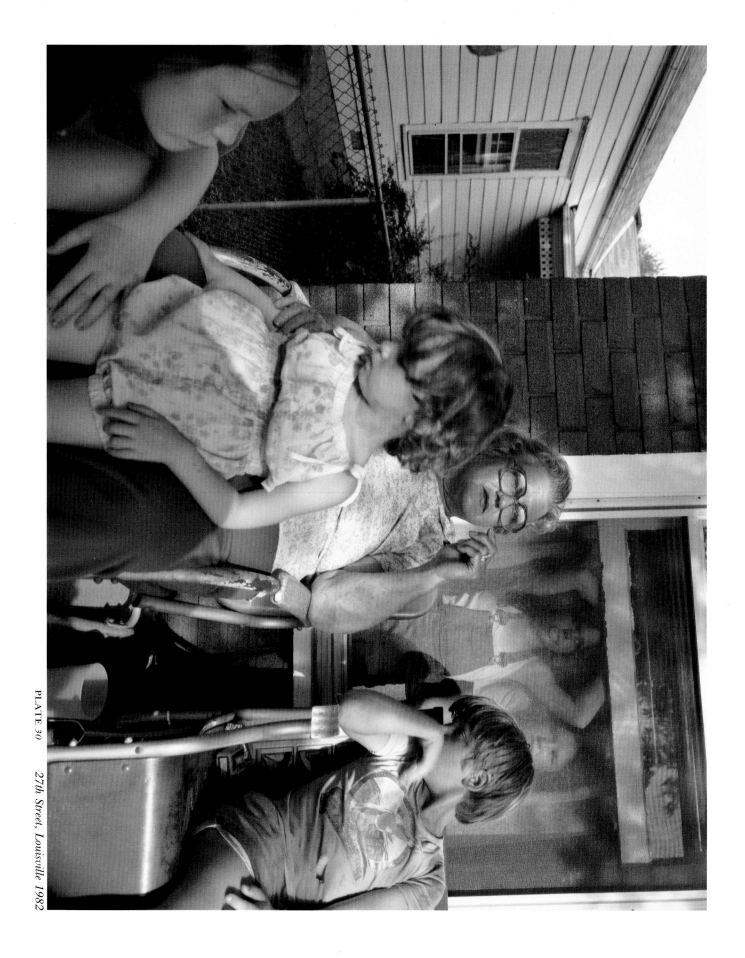

PLATE 30 *27th Street, Louisville 1982*

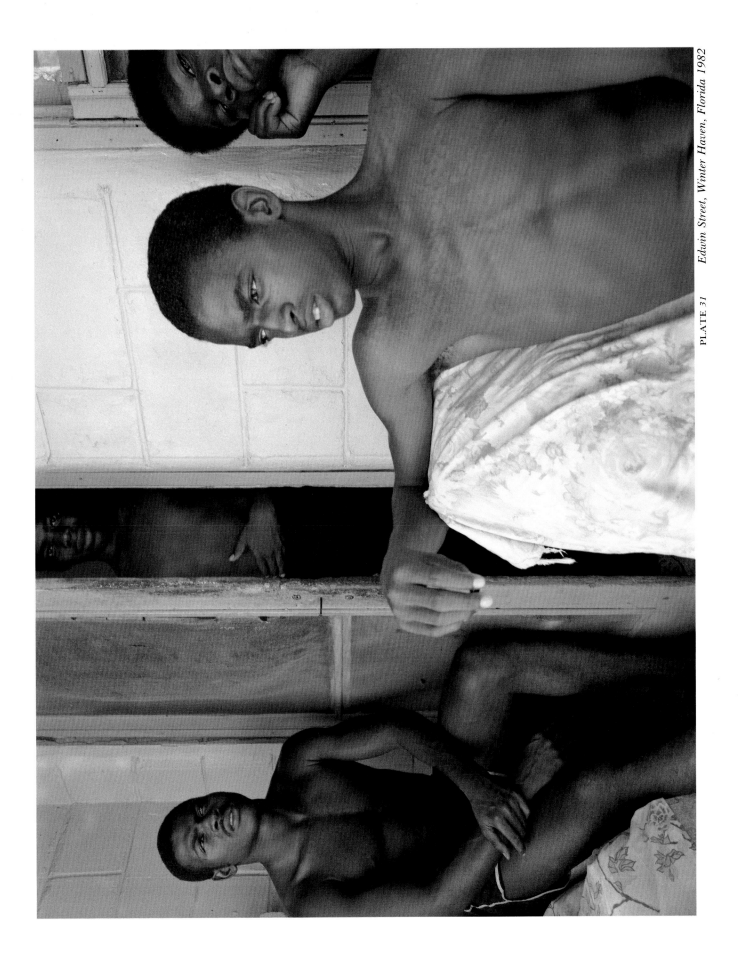

PLATE 31 Edwin Street, Winter Haven, Florida 1982

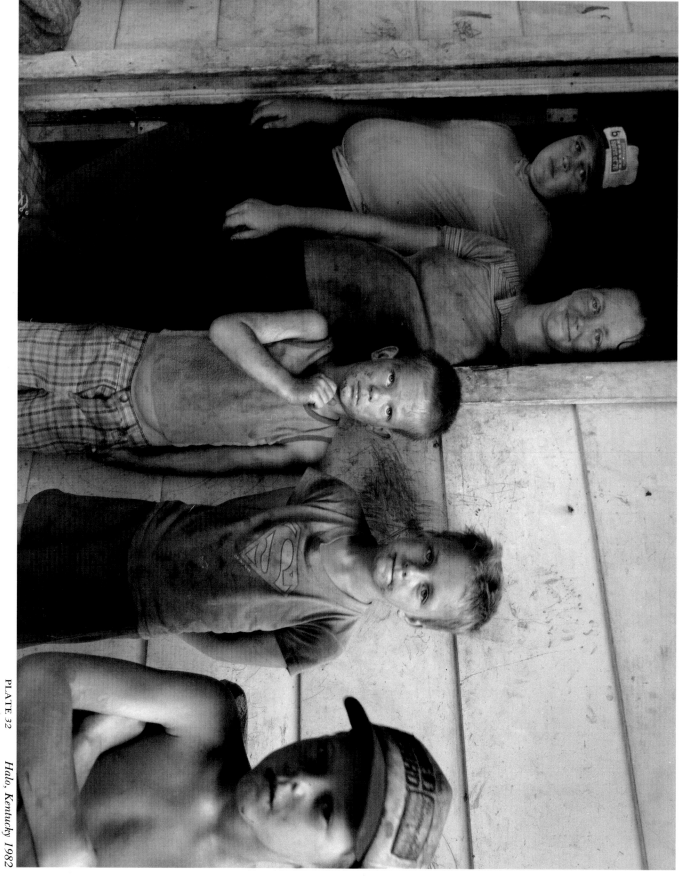

PLATE 32 *Halo, Kentucky 1982*

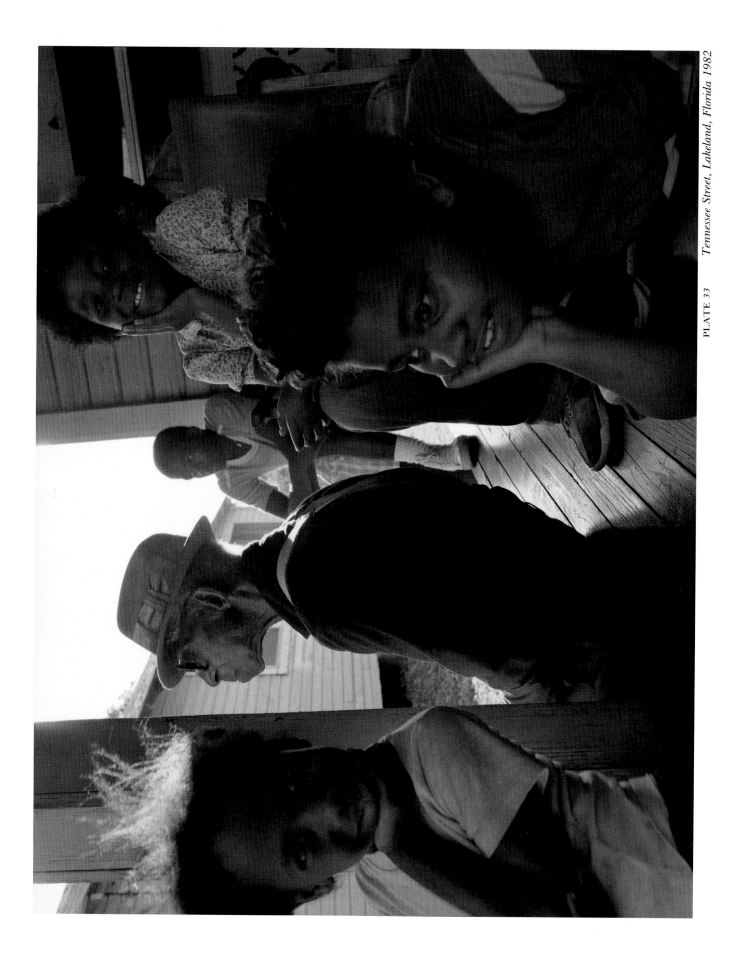

PLATE 33 *Tennessee Street, Lakeland, Florida 1982*

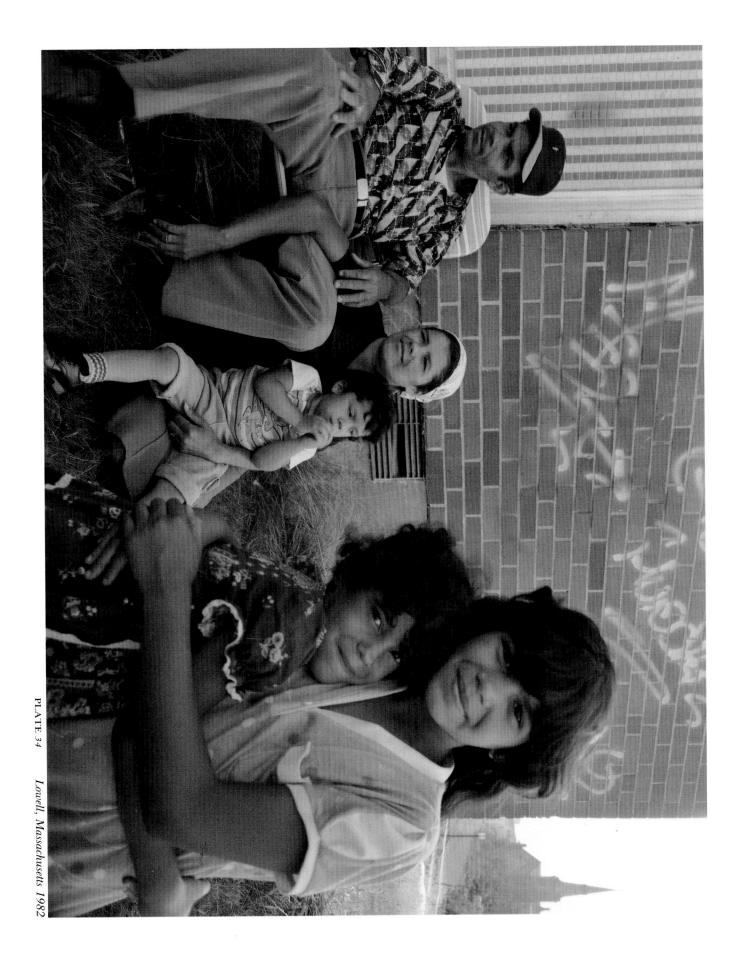

PLATE 34 Lowell, Massachusetts 1982

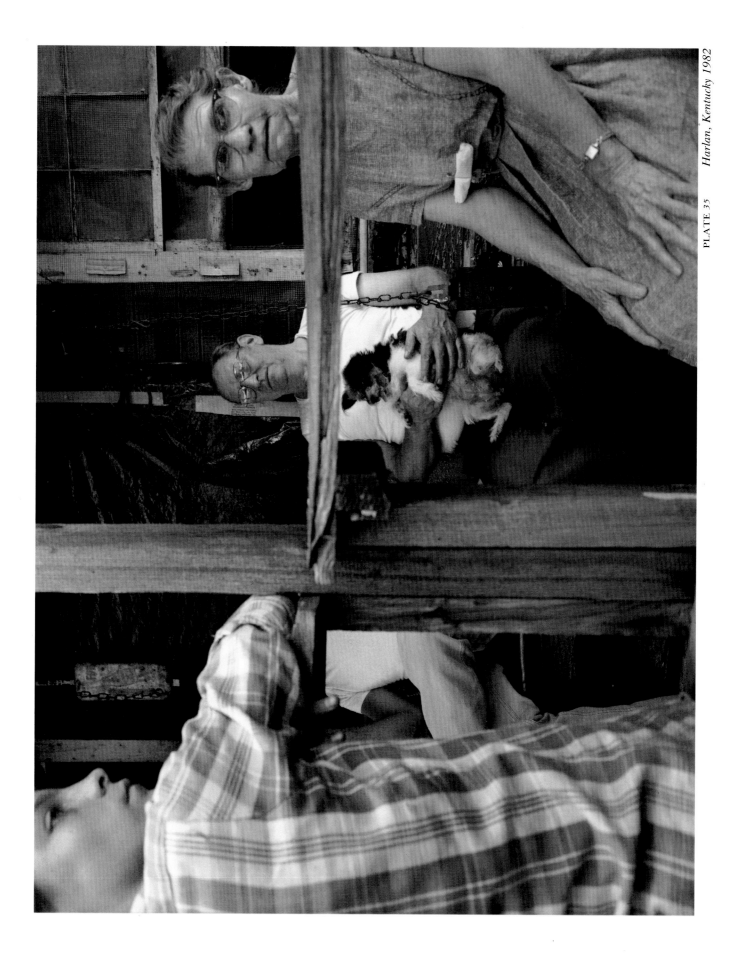

PLATE 35 Harlan, Kentucky 1982

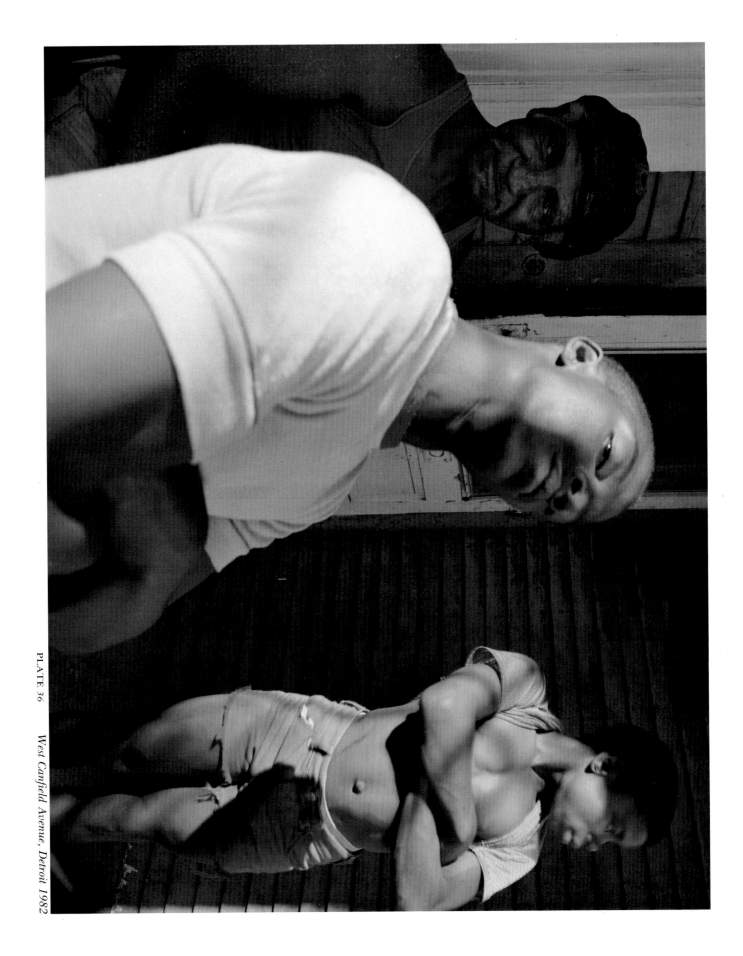

PLATE 36

West Canfield Avenue, Detroit 1982

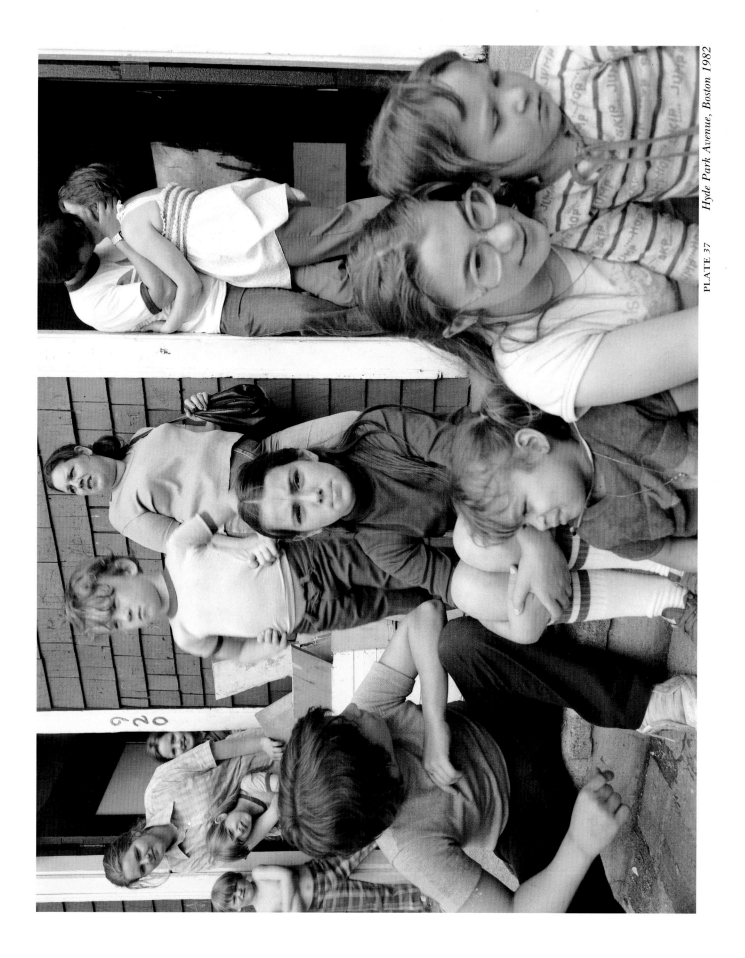

PLATE 37 Hyde Park Avenue, Boston 1982

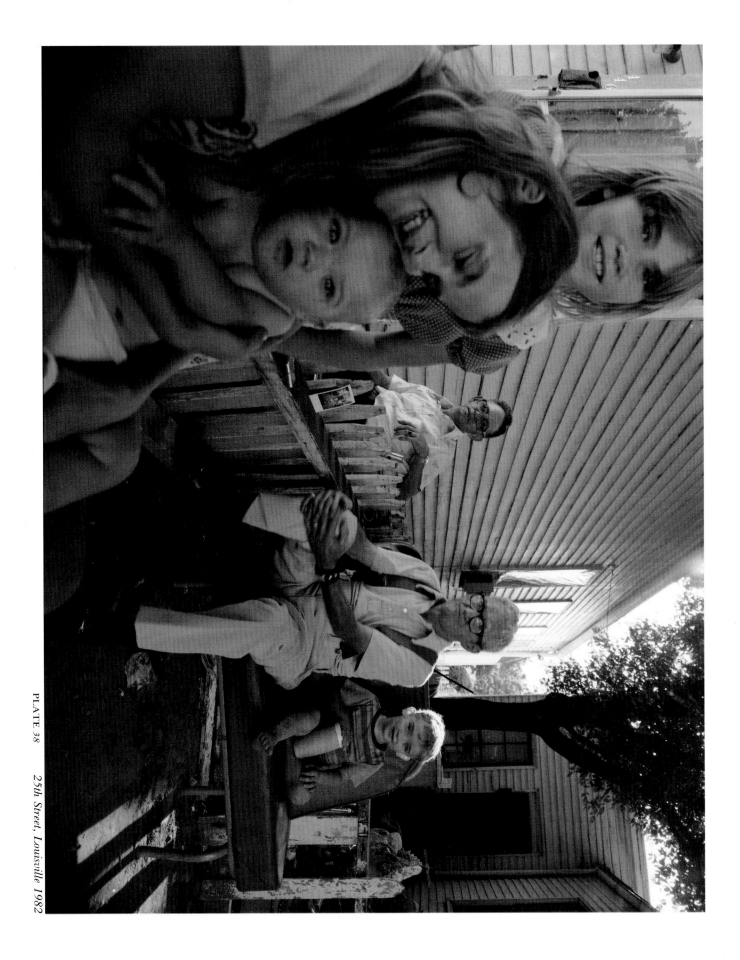

PLATE 38 25th Street, Louisville 1982

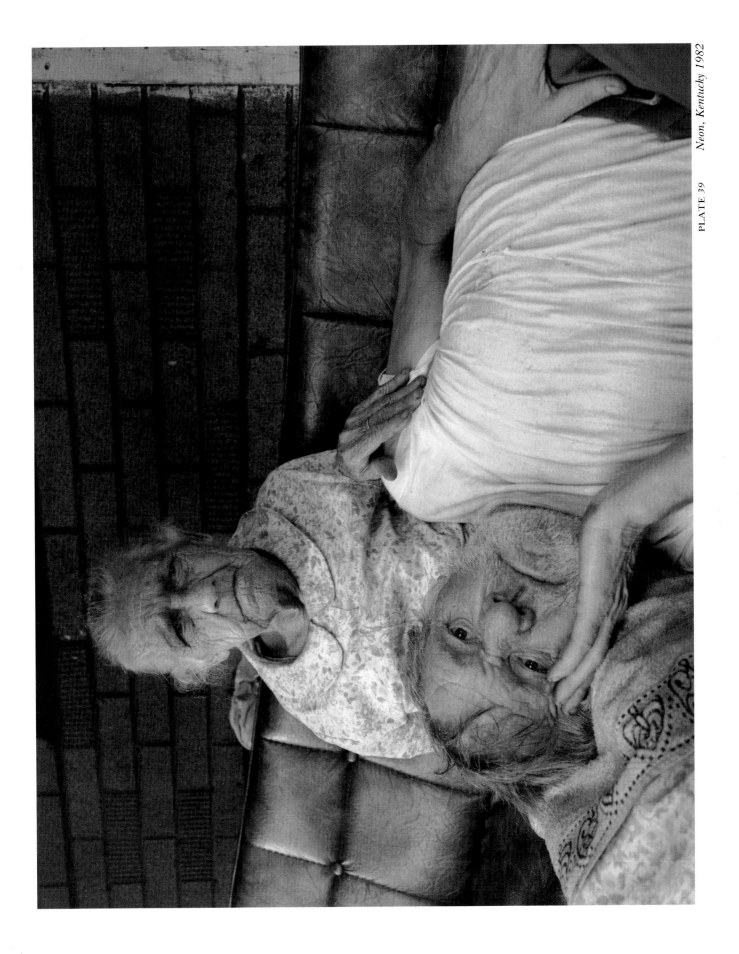

PLATE 39 *Neon, Kentucky 1982*

Chronology

Born Detroit, Michigan, 1947
B.A., American Literature, University of Michigan, 1969
M.F.A., University of New Mexico, 1974
Currently Associate Professor, Massachusetts College of Art, Boston

ONE-MAN EXHIBITIONS

1976 Museum of Modern Art, New York
1977 Vision Gallery, Boston
1978 Light Gallery, New York
1979 Light Gallery, New York
Vision Gallery, Boston
1980 Jeffrey Fraenkel Gallery, San Francisco
Light Gallery, New York
Vision Gallery, Boston
1981 Light Gallery, New York
1982 Jeffrey Fraenkel Gallery, San Francisco
Institute of Contemporary Art, Boston
Rochester Institute of Technology, Rochester, New York

SELECTED GROUP EXHIBITIONS

1975 *New Topographics,* International Museum of Photography at George Eastman House
1976 *Recent Acquisitions,* Museum of Modern Art, New York
1977 *Nicholas Nixon & Stephen Shore,* Worcester Art Museum, Worcester, Massachusetts
1978 *Mirrors & Windows: American Photography Since 1960,* Museum of Modern Art, New York
1979 *American Images,* Corcoran Gallery of Art, Washington, D.C.
1981 *American Children,* Museum of Modern Art, New York

AWARDS

1976 National Endowment for the Arts Photographer's Fellowship
1977 John Simon Guggenheim Memorial Fellowship
1980 National Endowment for the Arts Photographer's Fellowship
1982 Massachusetts Council for the Arts "New Works" grant

COLLECTIONS

Chicago Art Institute
Denver Art Museum
Fogg Art Museum, Harvard University
International Museum of Photography at George Eastman House
Metropolitan Museum of Art, New York
Minneapolis Institute of Art
Museum of Fine Arts, Boston
Museum of Fine Arts, Houston
Museum of Modern Art, New York
San Diego Museum of Art
Seagram Collection, New York
St. Louis Art Museum
Worcester Art Museum, Worcester, Massachusetts

BOOKS & CATALOGUES

1975 *New Topographics,* William Jenkins, ed. Rochester, New York: International Museum of Photography at George Eastman House.
1977 *Photography Year,* New York: Time Life Books.
American Photographic Works, Lewis Baltz, ed. Houston: Museum of Fine Arts.
1978 *Courthouse,* Richard Pare, ed. New York: Horizon.
Mirrors and Windows, John Szarkowski, ed. New York: Museum of Modern Art.
1979 *American Images,* Renato Danese, ed. New York: McGraw-Hill.
1981 *American Children,* Susan Kismaric. New York: Museum of Modern Art.
1983 *Nicholas Nixon: Photographs from One Year (Untitled 31).* Carmel: The Friends of Photography.